# BEYOND THE TINY WINDOW

# C L O U D S

Irene Kueh

**To All**

who share my passion for

the luminous, wispy, fluffy, picturesque

~ C L O U D S ~

~*~*~*~

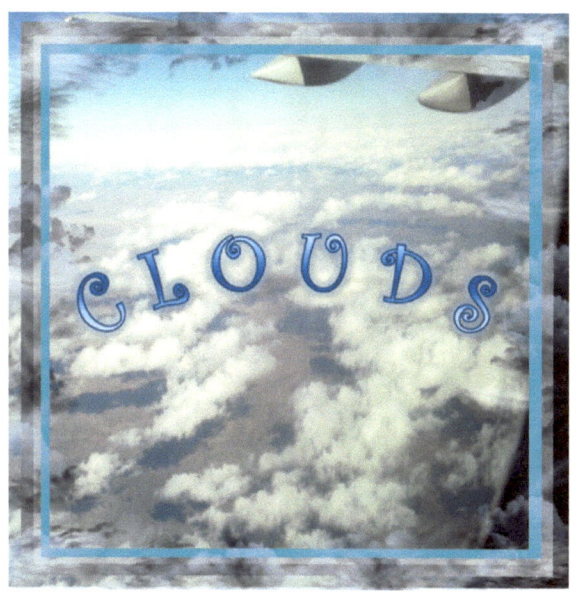

~*~*~*~

Let's begin this journey with a short story :

Little Jack & The Cloud

This story is dedicated to

Isaiah Shelden Kueh Dennis

Happy Second Birthday, Mama's Little Precious!

## ... Little Jack & The Cloud ...

Today is Little Jack's birthday. Mommy and Daddy celebrate his birthday party in the park. His grandfathers and grandmothers, uncles and aunts are all there. He and his brother, Noel, and their friends and cousins run and roll in the grass. They laugh and play together.

"Kids, come to the table," calls Mommy.

They all stop playing and run toward the table.

Noel stands next to Mommy and tugs at her skirt. "What are we doing now Mommy?" he asks.

Mommy smiles and ruffles Noel's hair. "It's a surprise."

Noel smiles back and whispers, "Is it cake time?"

Little Jack appears right behind them and asks loudly, "What, Noel?"

"Nothing," said Noel. He quickly covers his mouth.

"Sit down, both of you," said Mommy.

Little Jack sits down next to Noel and swings his legs. A few seconds later, Daddy comes out from their car.

"Daddy," said Little Jack as he points at Daddy as he walks toward the table.

Daddy is carrying a big round cake with two long, red candles. Everybody claps their hands and sings:

*Happy birthday to you*
*Happy birthday to you*
*Happy birthday Dear Little Jack*
*Happy birthday to you*

Daddy puts the cake down in front of Little Jack. There are so many tiny balls around the edge and in the middle.

"Balls," says Little Jack.

"Make a wish," says Daddy.

Little Jack looks up into the sky. The sun shines brightly over his face. He squints at the sky. It's blue but there's something white floating up there. He points toward it.

"Balloon," he says.

Daddy bends down and says, "No, that's a cloud."

Little Jack wrinkles his forehead. Mommy kisses his head and says. "It looks like a balloon, doesn't it?"

Little Jack nods and smiles. "Yes."

"Clouds float in the sky and they give us rain," said Mommy. "You love rain, don't you?"

Little Jack nods. "Love rain... Love cloud."

"Yes, we all love clouds," says Daddy. "Now make a wish, Little Jack and blow out the candles."

Little Jack looks at the cloud one more time, closes his eyes, and makes his wish. He opens his eyes and blows out the candles. Everyone claps their hands. Mommy cuts the cake and gives him a big piece with three colorful balls on it.

After Little Jack eats his yummy cake, he opens his presents. He gets so many toys. He, his brother, and friends play with the toys until the sun disappears. They stop playing and put all the toys in their car.

Little Jack grabs a red ball and looks up. There are so many clouds now and they are colorful. "Bye bye, Clouds." He waves and gets inside the car.

That night, when Little Jack climbs into his bed, he hears a soft knock on the window. He stands on his pillow and pulls the curtains aside. His eyes grow big. The same small white balloon he saw at the park is floating by his tiny window. He quickly opens it.

"Balloon... Ooops!" He covers his mouth. "Cloud," he says.

"Yes, it's me," says the Cloud. "Happy Birthday, Little Jack."

"Birthday." He points his chest.

"Yes," says the Cloud. "I'm here to make your wish come true."

"Hug Cloud," says Little Jack.

The Cloud floats closer toward the window. Little Jack leans out and hugs it. "Friends," he says.

"Yes, we're friends now," says the Cloud. "If you need me, you know where to find me, don't you?"

Little Jack points toward the sky. The Cloud nods.

"Yes," says the Cloud. "I'll always be there for you, Little Jack. I'm your friend for life. Now, go to bed. Sweet dreams." The Cloud hugs Little Jack again and floats away.

Little Jack looks out his tiny window until the Cloud disappears. He closes the window and goes to bed with a big smile on his face.

And Little Jack dreams of his new friend for life... The Cloud...

# BEYOND THE TINY WINDOW

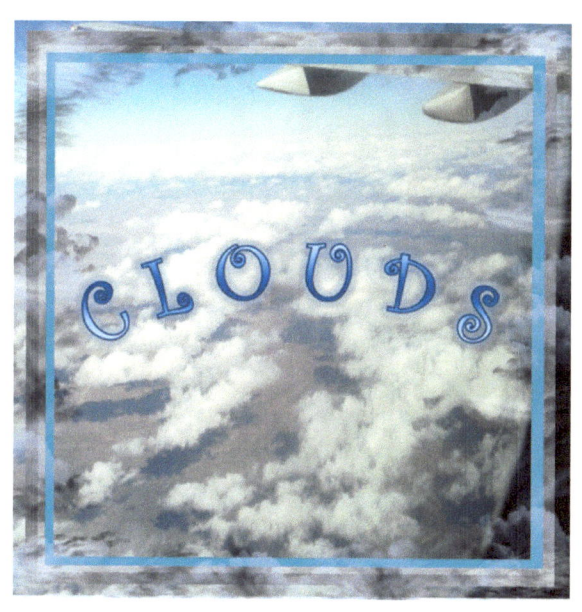

~ * ~ * ~ * ~

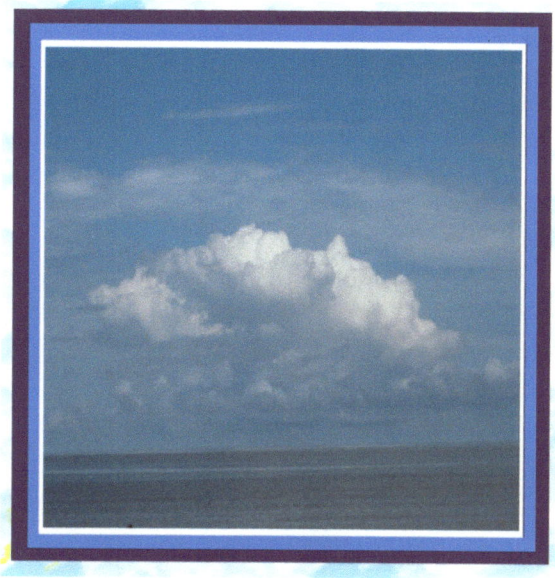

~ * ~ * ~ * ~

**To the Clouds**
**I whisper my Dreams**

~ * ~ * ~ * ~

~ * ~ * ~ * ~

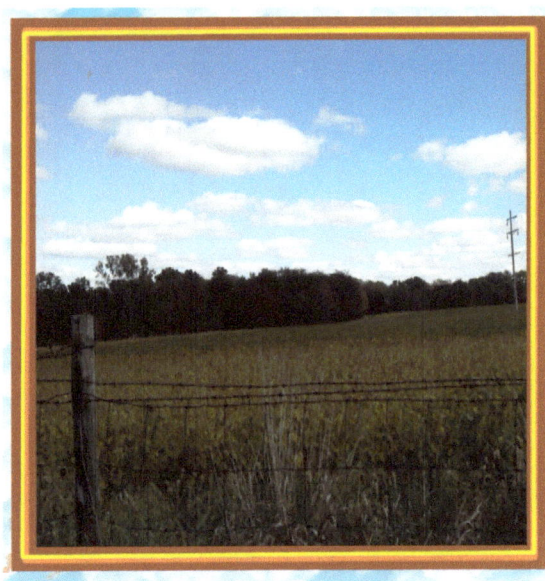

~ * ~ * ~ * ~

White as snow
Fluffy and pure
Make my love flow
And my heart soar

~ * ~ * ~ * ~

~ * ~ * ~ * ~

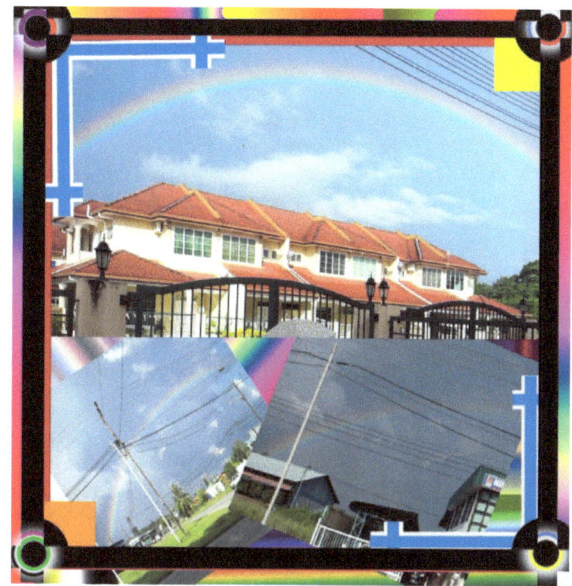

~ Kuching, Malaysia ~
...taken by Shirley Kueh & Dennis Abu...

~ * ~ * ~ * ~

**Exquisite clouds, picturesque rainbow**
**Strike my heart like a Cupid's arrow**

~ * ~ * ~ * ~

~ * ~ * ~ * ~

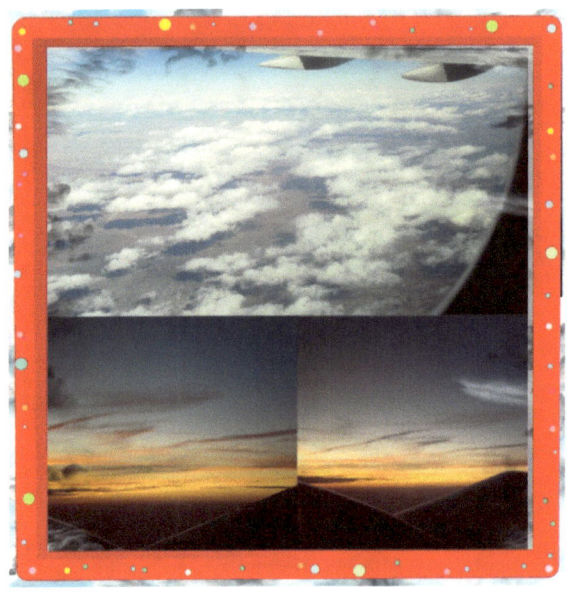

~ * ~ * ~ * ~

**Flying in the clouds**
**Watching the shadows**
**My eyes open wide**
**My soul yearns for more**

~ * ~ * ~ * ~

~ * ~ * ~ * ~

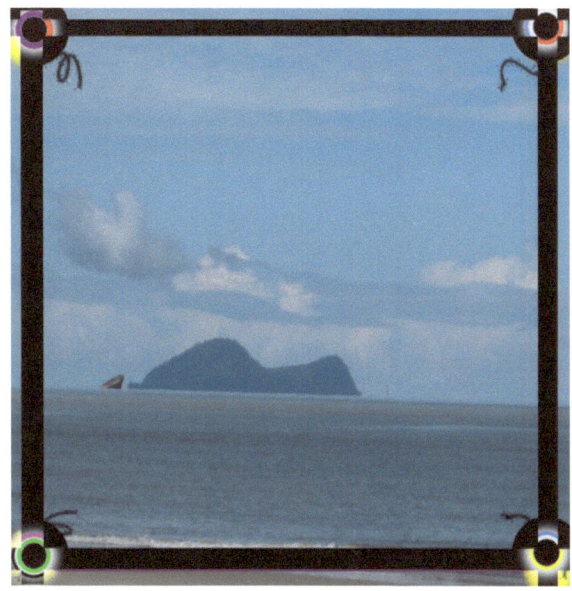

~ * ~ * ~ * ~

**Awan biru**
**Menyentuh kalbu**
**Hatiku rindu**
**Mengenangkanmu**

~ * ~ * ~ * ~

~*~*~*~

~*~*~*~

**Fly my dear Clouds, Fly
Reach the Heaven and make the Earth smile**

~*~*~*~

~ * ~ * ~ * ~

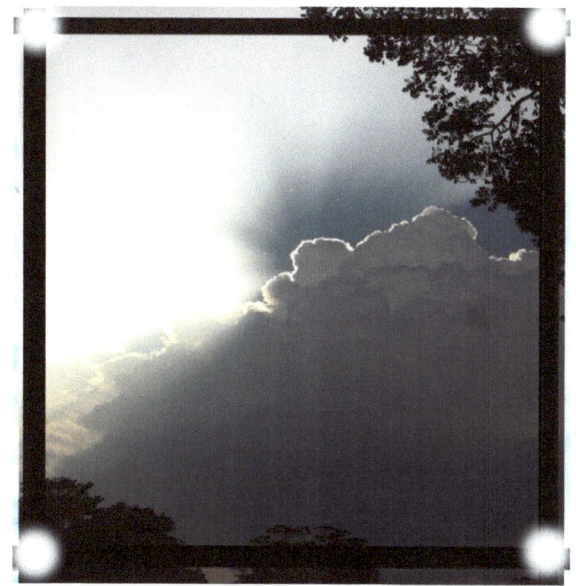

~ Kuching, Malaysia ~
...taken by Christina Tau Mei Ni...

~ * ~ * ~ * ~

**Today is My Best Day!**

~ * ~ * ~ * ~

~ * ~ * ~ * ~

~ * ~ * ~ * ~

... Amour ...
la ville, le ciel, les nuages d'amour

~ * ~ * ~ * ~

~ * ~ * ~ * ~

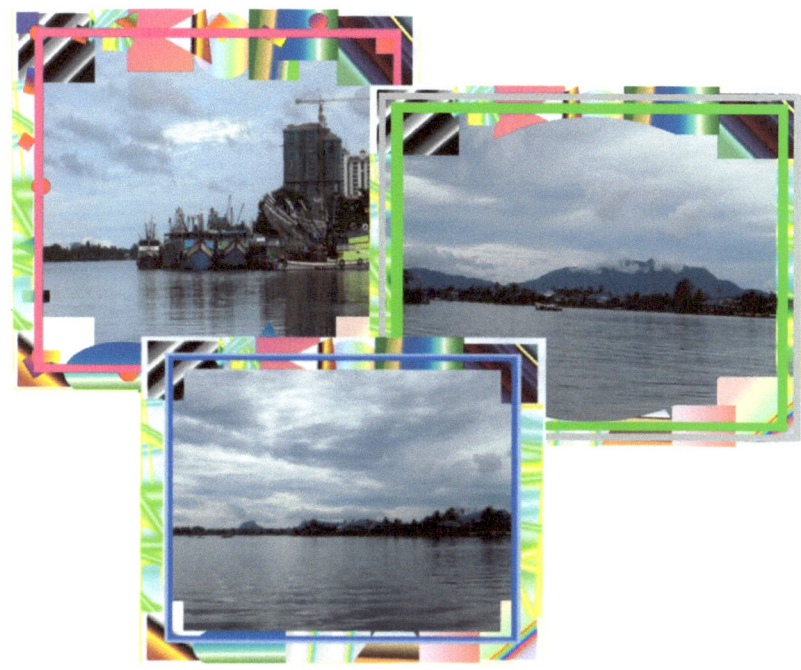

~ * ~ * ~ * ~

**Mendung awan**
**Berdetik hujan**
**Bagaikan airmata**
**Berlinang penuh duka**

~ * ~ * ~ * ~

~ * ~ * ~ * ~

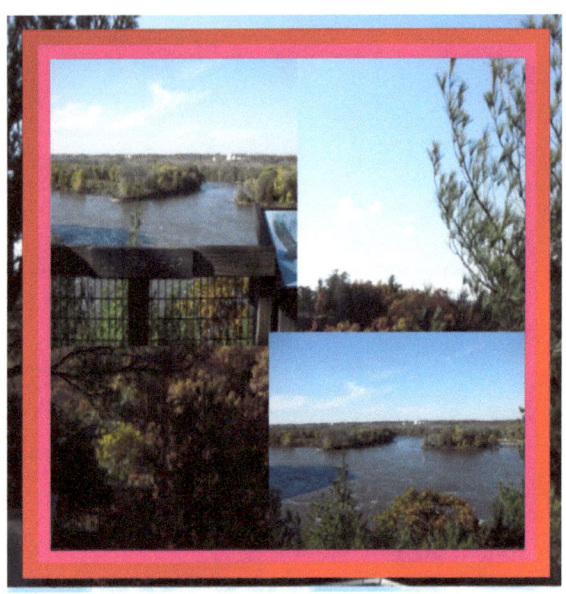

~ * ~ * ~ * ~

**I wish, I dream, I hope
To hold you in my heart
Till the end of time**

~ * ~ * ~ * ~

~ * ~ * ~ * ~

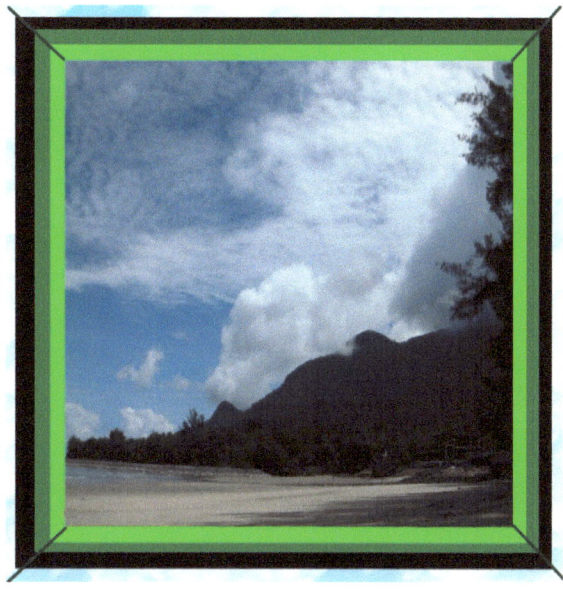

~ * ~ * ~ * ~

**In the clouds, I hide my deepest secret**

~ * ~ * ~ * ~

~ * ~ * ~ * ~

~ Kuala Lumpur, Malaysia ~
...taken/written by Catherine Cheng...

~ * ~ * ~ * ~

**That must be the magic wand for me
from that special one out there faraway...**

~ * ~ * ~ * ~

~ * ~ * ~ * ~

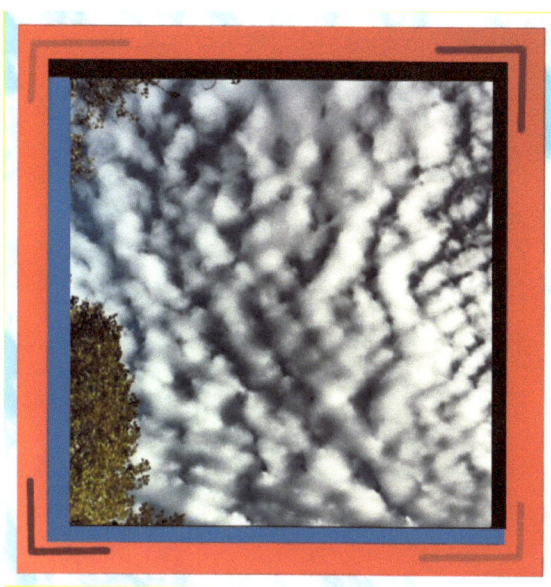

~ Cologne, Germany ~
…taken/written by Sabine Caroline…

~ * ~ * ~ * ~

**Wir unter Wolken, an dich denkend - fühl dich umarmt liebe Reny!**

~ * ~ * ~ * ~

~ * ~ * ~ * ~

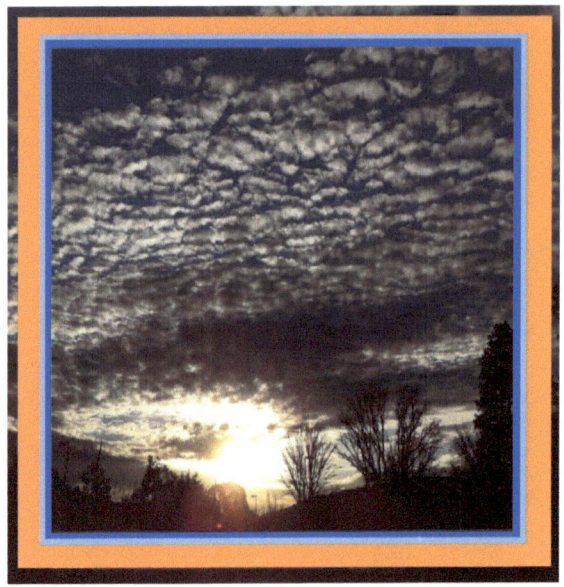

~ Canberra, Australia ~
...taken by Angie Tay...

~ * ~ * ~ * ~

**You lift my soul toward the sky
You raise my heart toward the heavens**

~ * ~ * ~ * ~

~ * ~ * ~ * ~

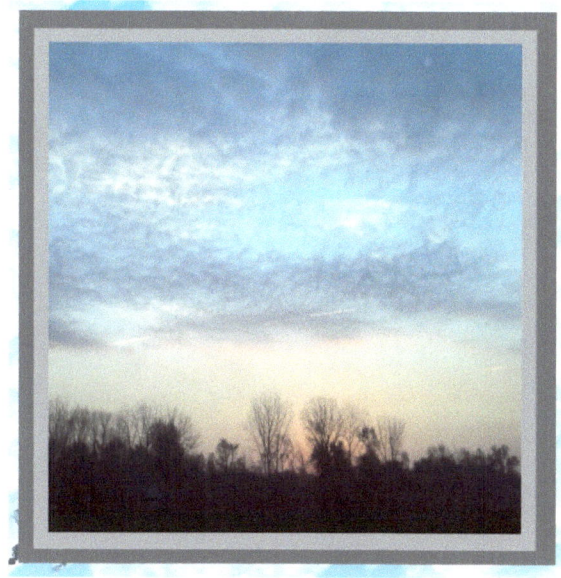

~ * ~ * ~ * ~

**You make me believe ...**

~ * ~ * ~ * ~

~ * ~ * ~ * ~

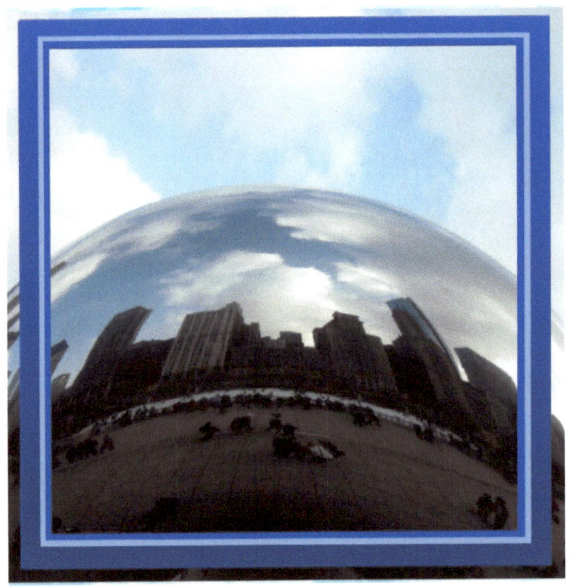

~ Milennium Park, Chicago ~

~ * ~ * ~ * ~

**The radiant clouds mirrored on my soul**

~ * ~ * ~ * ~

~ * ~ * ~ * ~

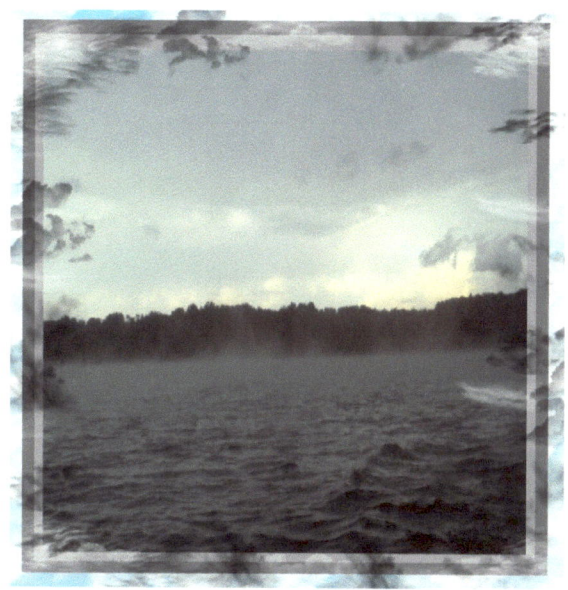

~ Clinton Lake, USA ~

~ * ~ * ~ * ~

**The foggy lake**
**The raging wind**
**The tempestuous waves**
**The nefarious clouds**
**...The unforgettable day...**

~ * ~ * ~ * ~

~ * ~ * ~ * ~

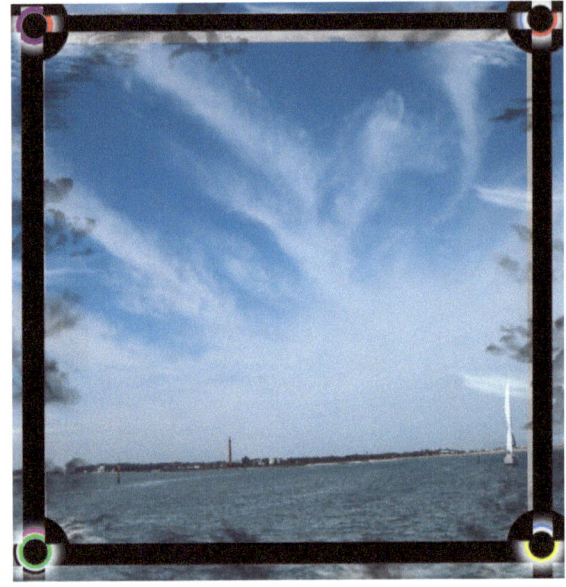

~ Daytona Beach, USA ~

~ * ~ * ~ * ~

**I see dolphins dance in the ocean
I scrawl your name across the sky**

~ * ~ * ~ * ~

~ * ~ * ~ * ~

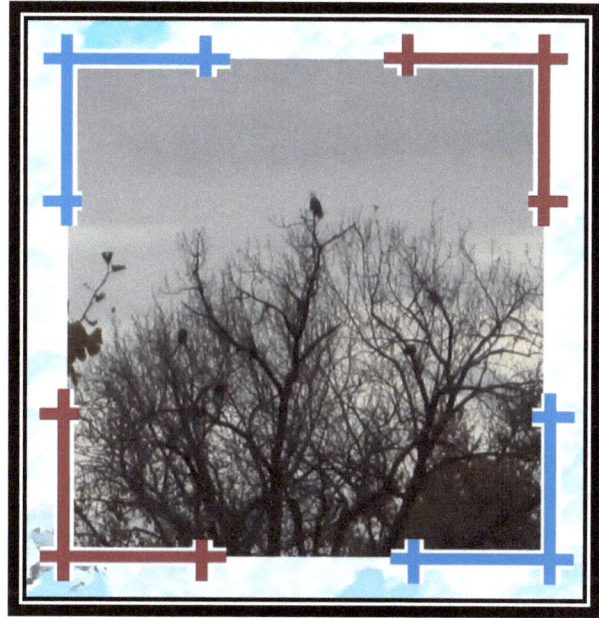

~ Starved Rock, USA ~

~ * ~ * ~ * ~

**…Eagle…**
**The king of the sky**
**Forever vigilant**

~ * ~ * ~ * ~

~*~*~*~

~*~*~*~

**Spread over the land with your majestic beauty**

~*~*~*~

~ * ~ * ~ * ~

~ * ~ * ~ * ~

**Trees and clouds
Nature's gift to us**

~ * ~ * ~ * ~

~ * ~ * ~ * ~

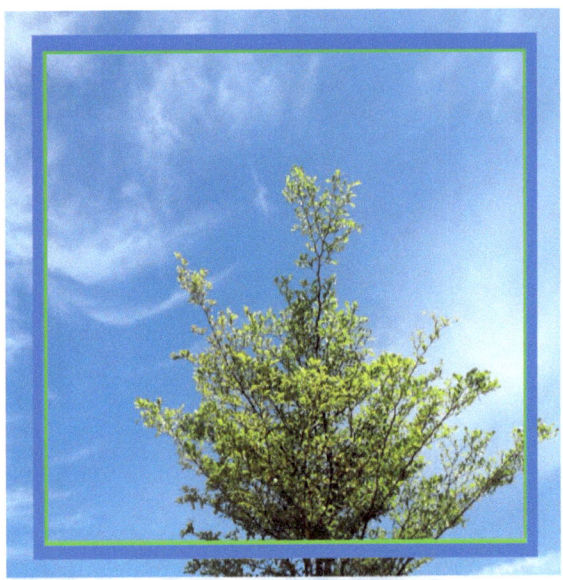

~ Bucida layered tree, Malaysia ~
...taken/written by Catherine Cheng...

~ * ~ * ~ * ~

**I wish you are here
enjoying this breezy, bright, and beautiful day**

~ * ~ * ~ * ~

~ * ~ * ~ * ~

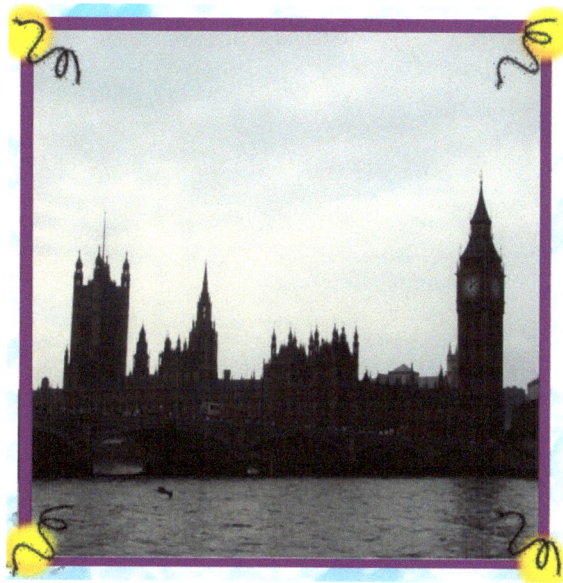

~ * ~ * ~ * ~

**Unpredictable skies eye the royal land
Oh Clouds, shield my heart from unpredictable pain**

~ * ~ * ~ * ~

~ * ~ * ~ * ~

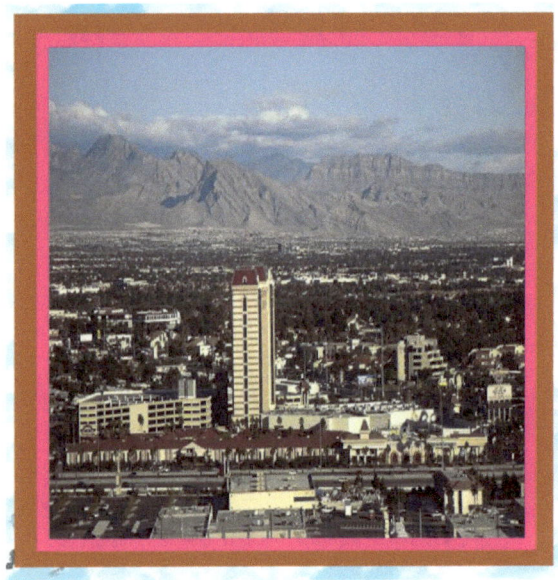

~ Las Vegas, USA ~

~ * ~ * ~ * ~

**Whatever happens on this land
Stays in the clouds of this sky**

~ * ~ * ~ * ~

~ * ~ * ~ * ~

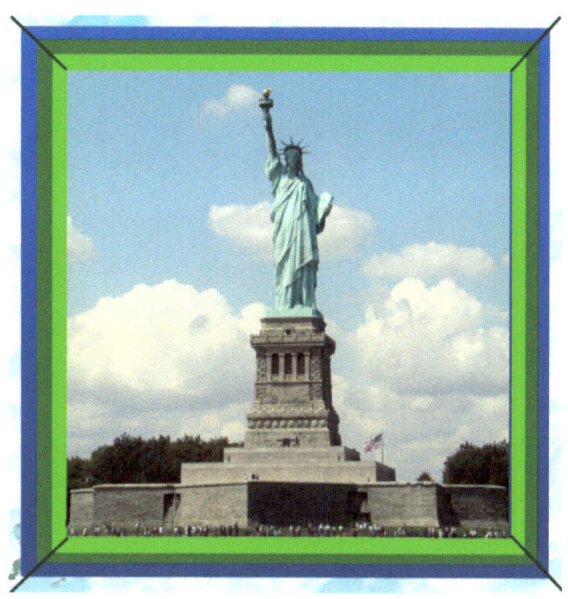

~ * ~ * ~ * ~

**United We Stand!**

~ * ~ * ~ * ~

~ * ~ * ~ * ~

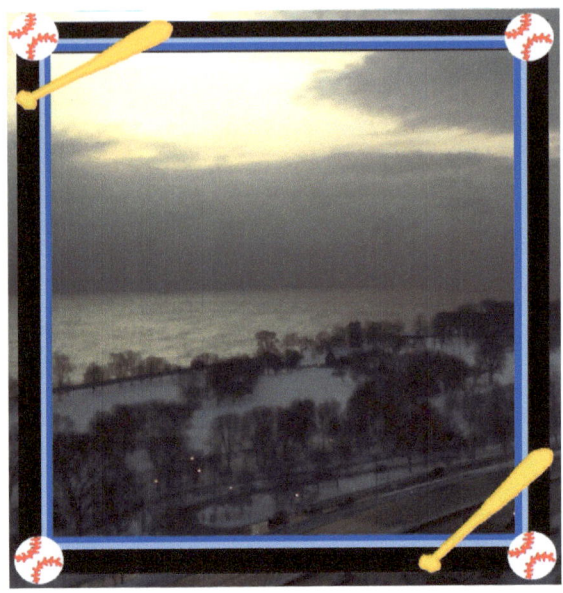

~ Lake Shore Drive ~
Chicago

~ * ~ * ~ * ~

**Come, let's go to the ballgame
and watch a home run kiss the clouds in the sky**

~ * ~ * ~ * ~

~ * ~ * ~ * ~

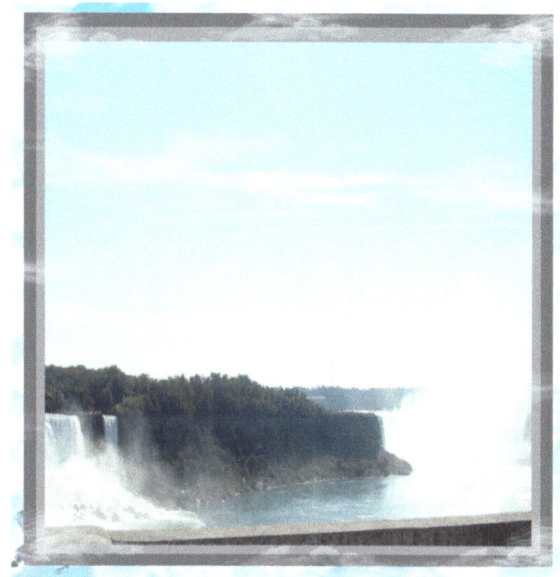

~ Niagara Falls ~

~ * ~ * ~ * ~

**Bluest sky**
**Fairest clouds**
**Steamy air**
**Awestruck view**
**That sums the great Niagara Falls**

~ * ~ * ~ * ~

~ \* ~ \* ~ \* ~

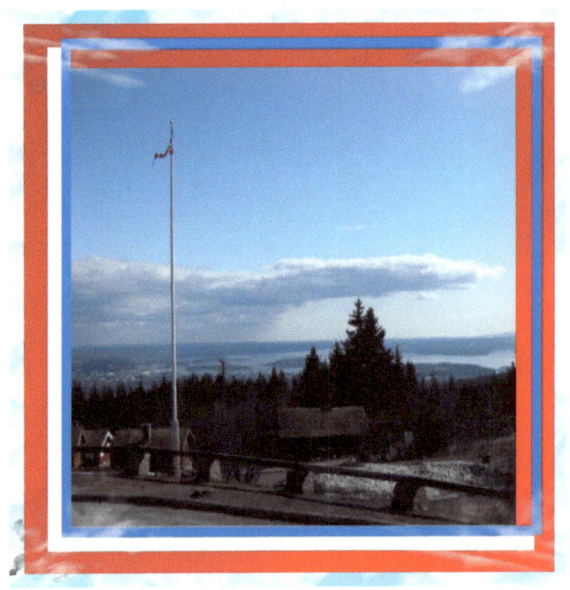

~ \* ~ \* ~ \* ~

**Oh Scandinavian Clouds**
**Fill my soul with your songs**

~ \* ~ \* ~ \* ~

~ * ~ * ~ * ~

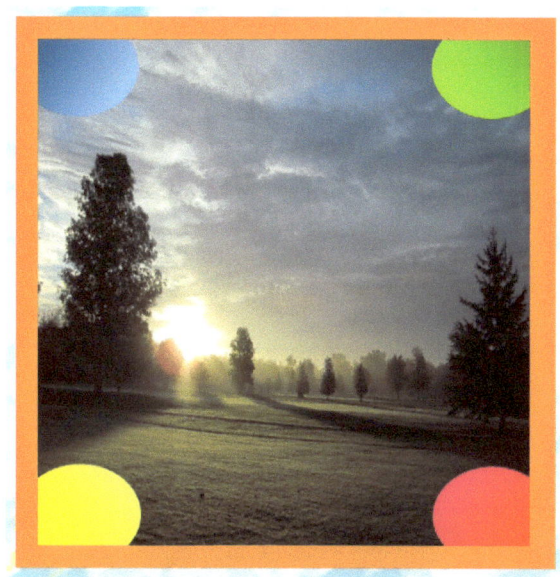

~ Metcalfe, Ontario, Canada ~
...taken by Andy Miles...

~ * ~ * ~ * ~

**Hit an ace on the green**
**While the clouds cheering on**
**Now, that's a great feat!**

~ * ~ * ~ * ~

~ * ~ * ~ * ~

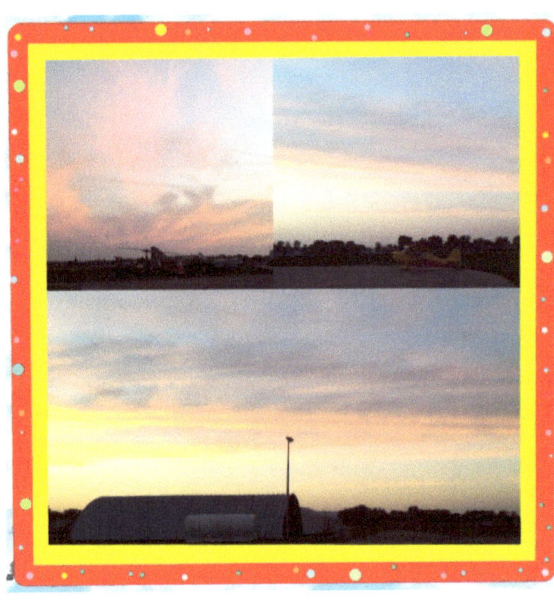

~ * ~ * ~ * ~

**I am humbled by thy existence**

~ * ~ * ~ * ~

~ * ~ * ~ * ~

~ * ~ * ~ * ~

**Oh clouds, calm my raging heart...**

~ * ~ * ~ * ~

~ * ~ * ~ * ~

~ Springfield, Illinois ~

~ * ~ * ~ * ~

**Droplets**
**Frozen crystal**
**Dancing in the air**
**Floating over my head**

~ * ~ * ~ * ~

~ * ~ * ~ * ~

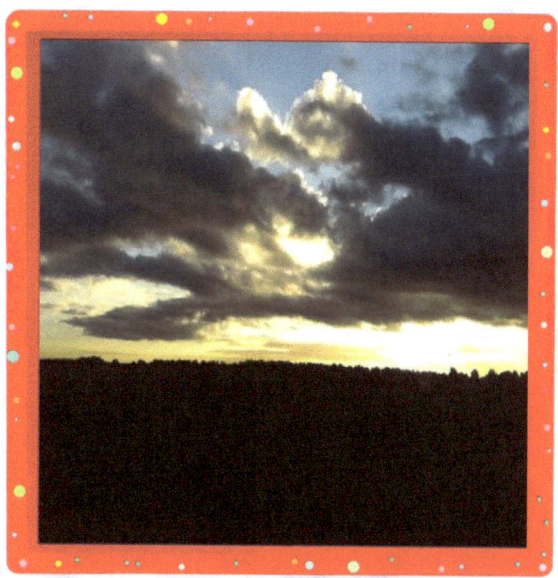

~ On the way from Brussels to Rotterdam~
...taken by Ivy Lim...

~ * ~ * ~ * ~

**There's always sunshine beyond the clouds**

~ * ~ * ~ * ~

~ * ~ * ~ * ~

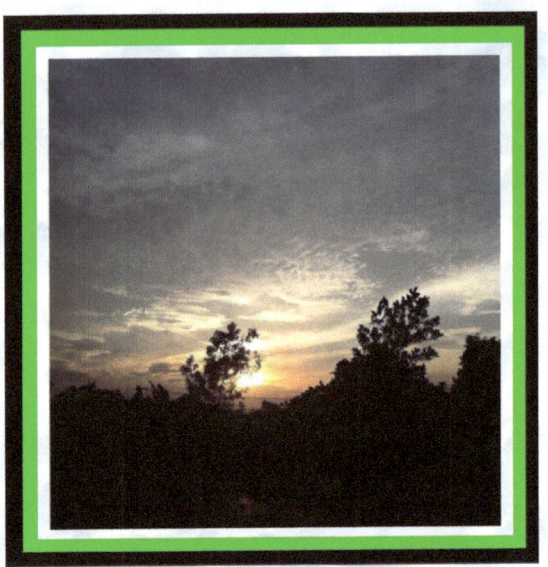

~ Kuching, Malaysia ~
...taken by Christina Tau Mei Ni...

~ * ~ * ~ * ~

**There's nothing better to start the day
than to be greeted by the alluring clouds in the sky**

~ * ~ * ~ * ~

~ * ~ * ~ * ~

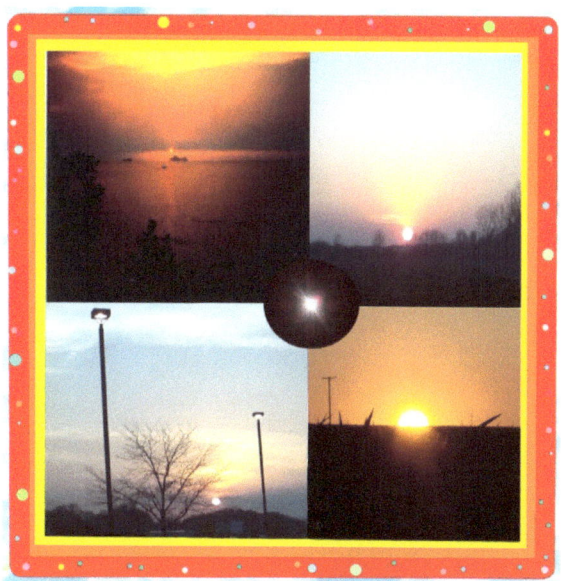

Bottom right taken by Don Mueller

~ * ~ * ~ * ~

**Thy beauty humbled my being
My lips exalted Thy name!**

~ * ~ * ~ * ~

~ * ~ * ~ * ~

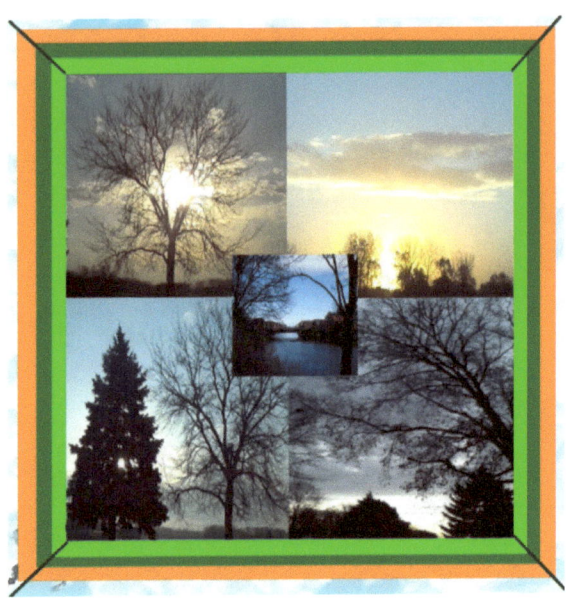

~ * ~ * ~ * ~

Oh trees, shelter me
Oh clouds, shield me
as I hide my tears
in my smile

~ * ~ * ~ * ~

~ * ~ * ~ * ~

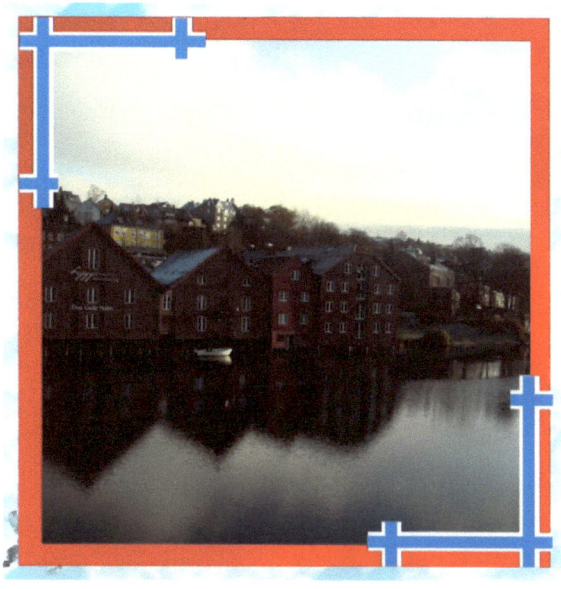

~ * ~ * ~ * ~

**Thy beauty is to me
Like the melody of a love song**

~ * ~ * ~ * ~

~ * ~ * ~ * ~

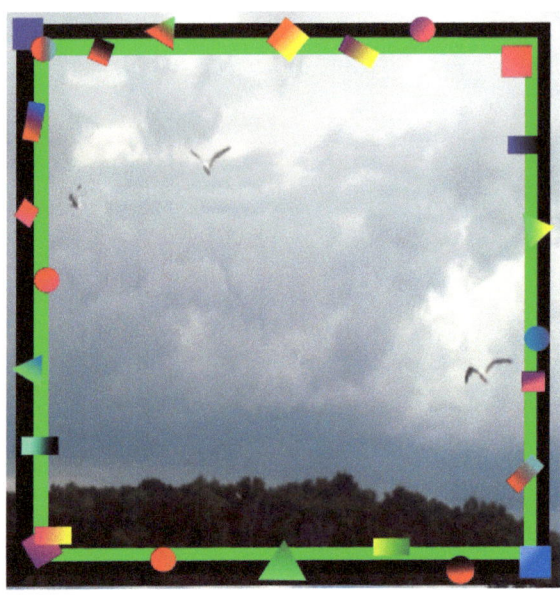

~ * ~ * ~ * ~

**Fly birdie, fly
Among the clouds
In the bluest sky**

~ * ~ * ~ * ~

~ * ~ * ~ * ~

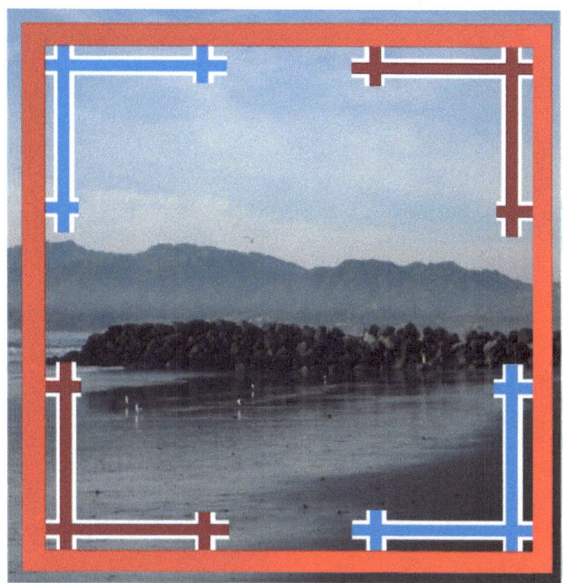

~ Venice Beach, California ~

~ * ~ * ~ * ~

**Picture Perfect:**
**The seagulls, the waves, the sandy beach**
**The flawless clouds up above**

~ * ~ * ~ * ~

~*~*~*~

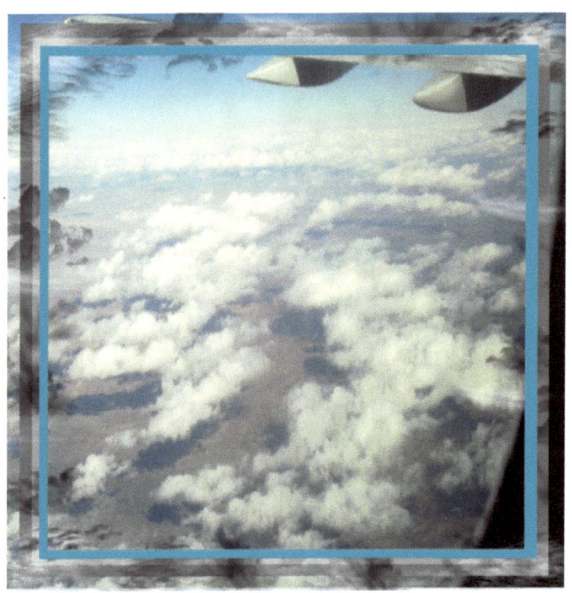

~*~*~*~

...You...
...started it all...

~*~*~*~

## ~ Notes ~

Did you wonder why I started "Beyond The Tiny Window": Cloud series?
And why Clouds?

My fascination with this white cottony stuff started two years ago. I was on the plane from Kota Kinabalu to Kuching. It was my first time ever flying from KK. Half way through, I looked out the tiny window. The plane flew right on top of these gigantic, white, fluffy clouds. Called me silly, called me peculiar, but when I saw the shadows upon the land cast by the clouds, my heart stirred. I had never witnessed such a beautiful sight in my life. That image is forever etched in my mind. From that day forward, I revere the clouds and they hold a special place in my heart. Thus, the fascination began.

This first series of "Beyond The Tiny Window" is not possible without these fantastic people who were willing to share with me and the world their beautiful pictures. So, to these friends and family, Thank You from the bottom of my heart. I couldn't have done this without you: (In alphabetical order) Angie Tay, Catherine Cheng, Christina Tau Mei Ni, Don Mueller, Ivy Lim, Sabine Caroline, Shirley Kueh & Dennis Abu, and those who wish to remain anonymous. To my writing buddies: Chrissy Peebles, H.H. Laura, June Bourgo, Jayde Scott, and Patricia Puddle, Thank You for helping me selecting the Title and the endless support! To my good friend, editor, and co-author in our children books Land And Sea series, Kathy Kesner, Thank You for taking the time to give me your valuable input on the story : Little Jack & The Cloud. Last but never the least, I thank the Lord above for His beautiful creation.

Be it be stratus, cirrus or cumulus or cumulonimbus, I hope you enjoy these Clouds as much as I do.

~ Peace ~

www.ingramcontent.com/pod-product-compliance
Lightning Source LLC
Chambersburg PA
CBHW050814180526
45159CB00004B/1662